My horses

I paint them

over and over

and over again

because

it's something

I cannot do.

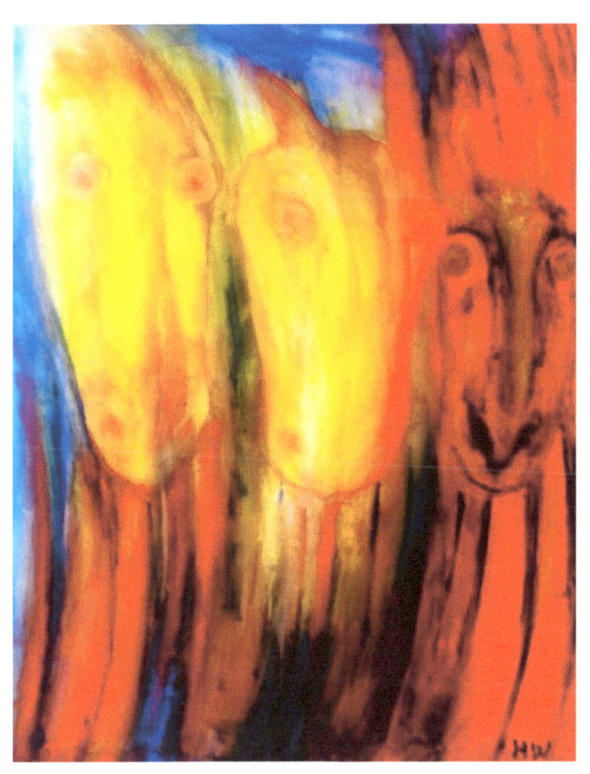

Always
horses,
I
paint them
always.

I
have always
painted
horses.

It
has been
almost
an obsession.

You can see
my mother
and
father and me
in the background.

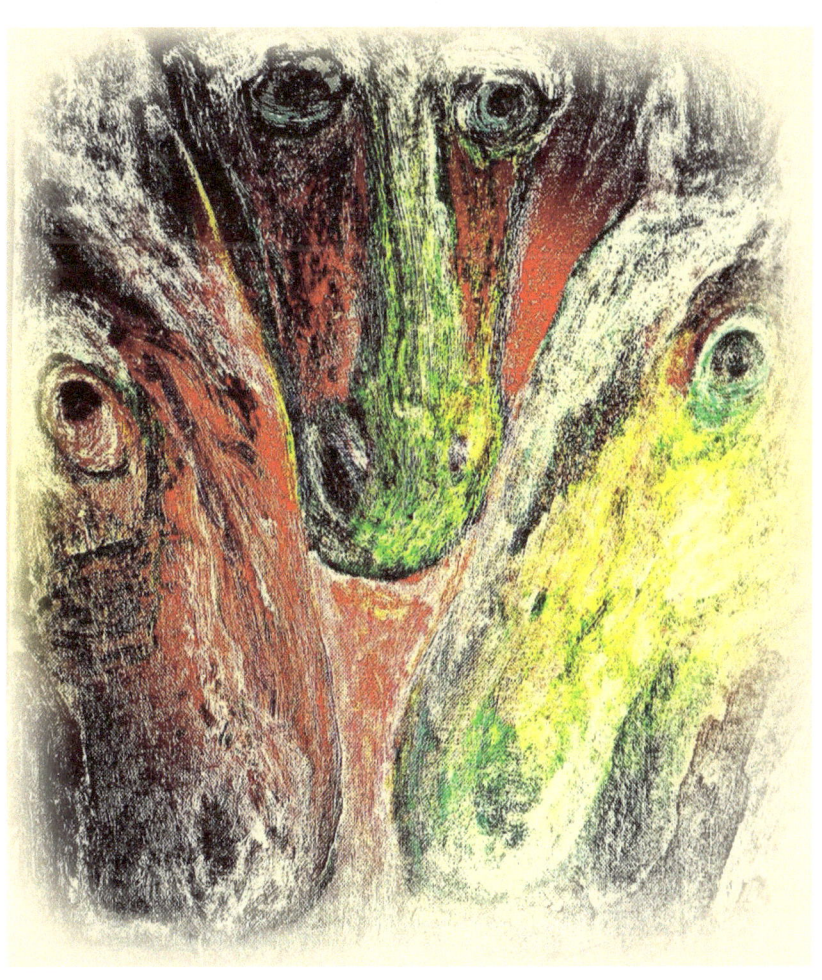

I was born
of a horse,
but I was not
a horse.

My horse was
my sister
and I
was her
head and will.

It
has been
almost
an obsession.

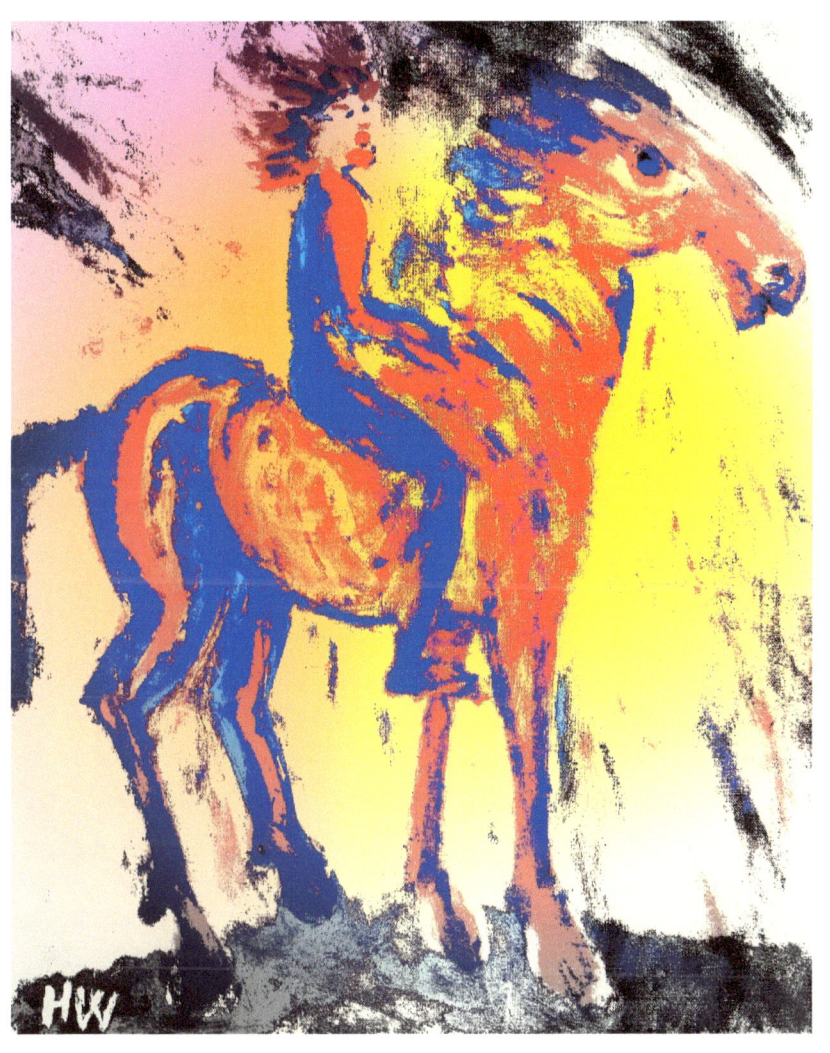

It
has been
almost
an obsession.

I
have always painted
you
my horse.
It has been
almost
an obsession.

Where
did my horse go?
Why
did she leave me?

My horse,
my
obsession.

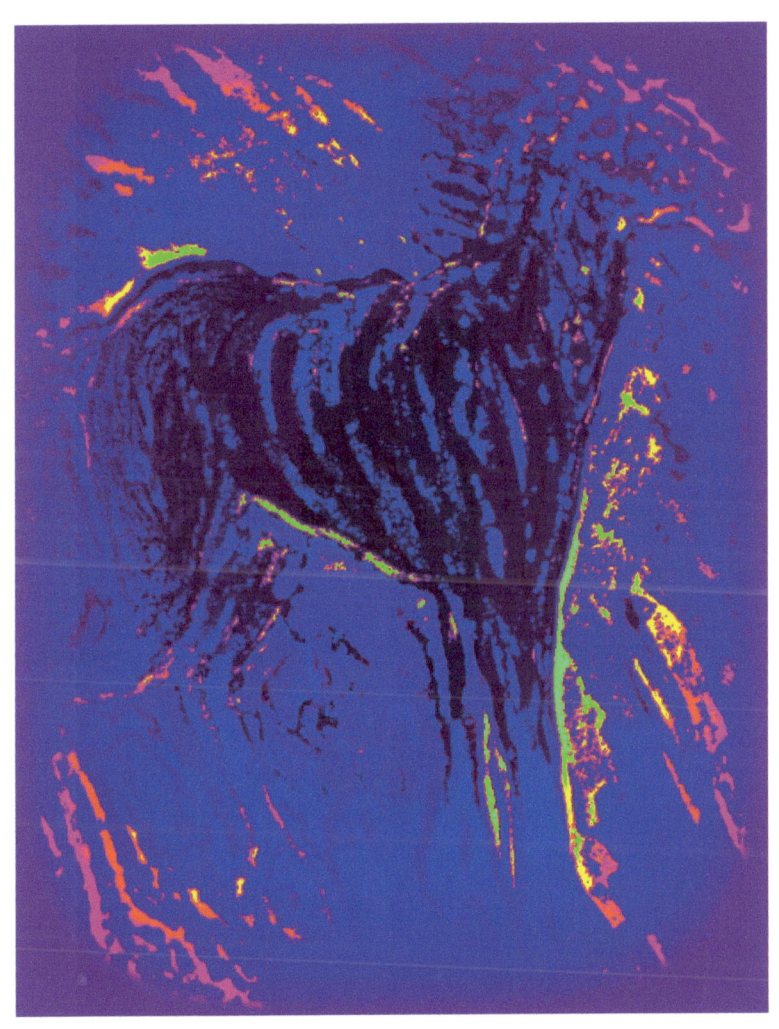

Life

is about love

and loneliness.

Life
is about loneliness,
and love
is about life.

You walk,
float or spiral
out of reach,
alone
or
in your heroic
solitude.

You walk,
float or spiral
out of reach.

I
cannot reach you
anymore.

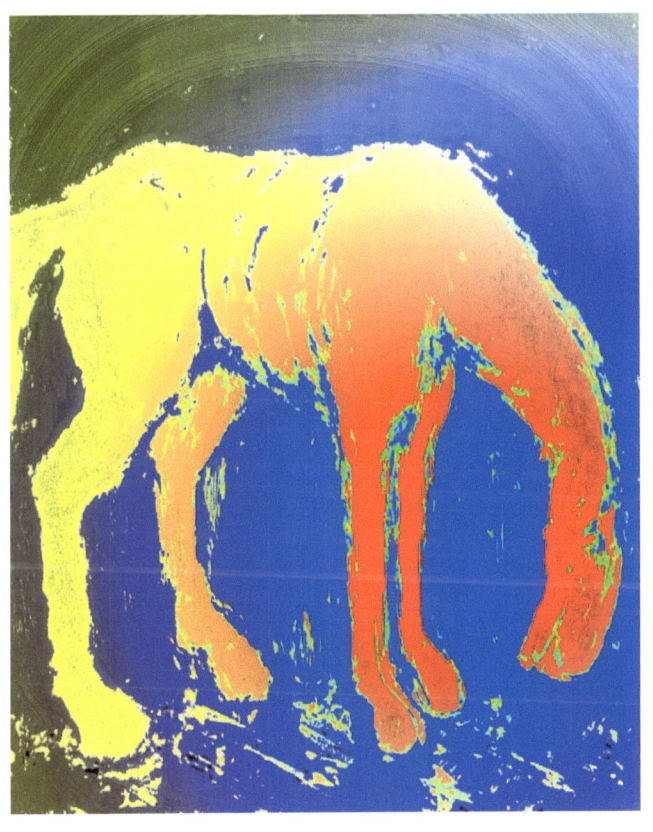

The horse is in me

and in you too.

I look forward

to the meeting

between me

my painting and

my horse

Life
is not
about individuals,
but about
timeless
human
existence.

Life
is also about
loneliness.

I miss you,
my horse.

We were meant
to be
together
and never
alone.

You have to let go
and let the feelings go.
The more insecure
and clumsy you are
and the less
control you have,
the better
will the horse be.

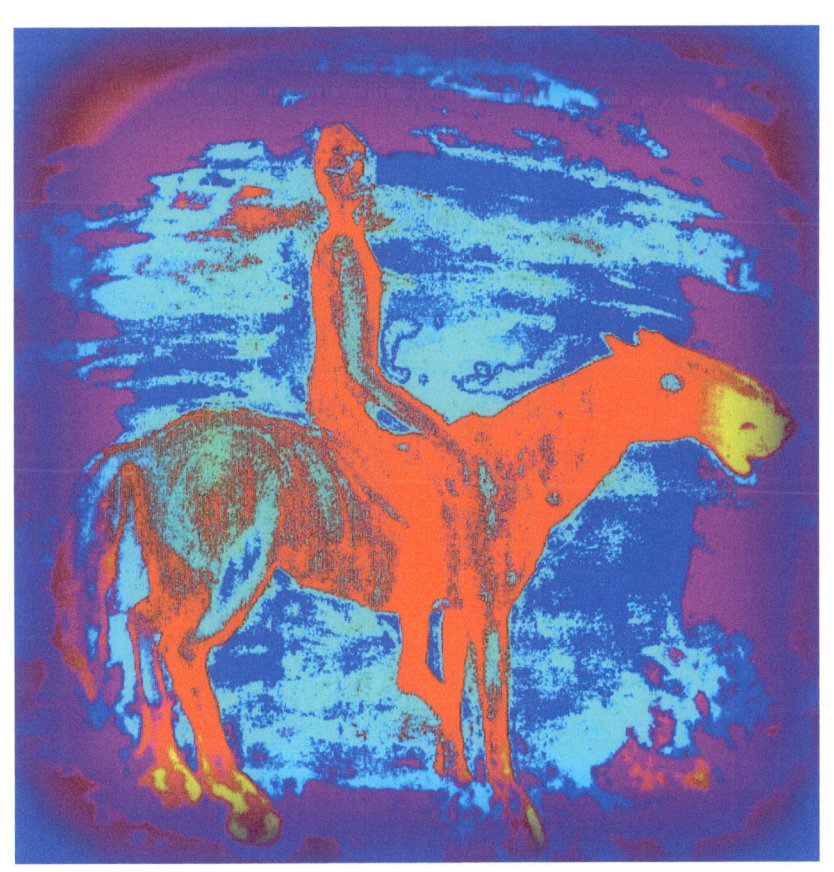

Some
are keen on
control,
to be in control,
to know
what's going on.

Others
devote themselves
to the extent
that they loose
control.

So I go on
painting my horses
because it's something
I cannot do.

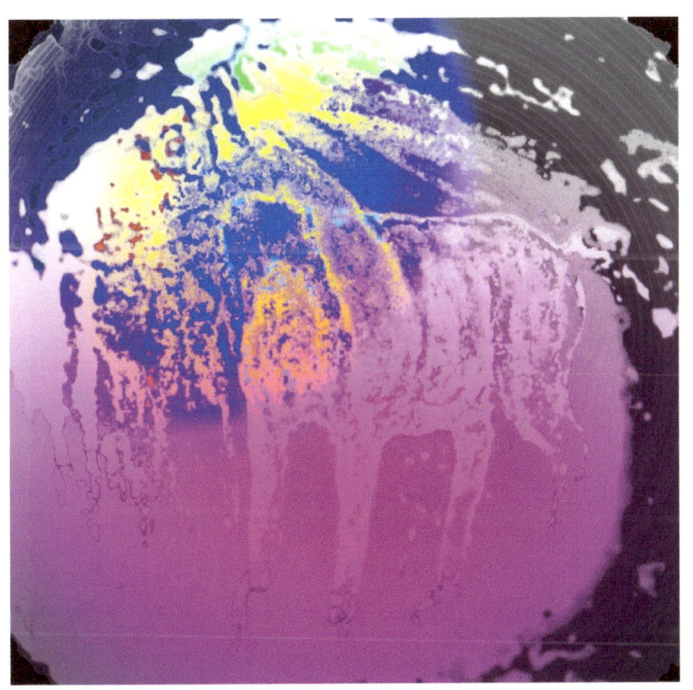

There are swiftly memories
of brushstrokes,
energetic and vibrant.

I have thought a lot
but I'm not good
at listening,
and I'm not good
at discussing
and I do not understand
other people or
their views.

Where
did my horse go?
Why
did she leave me?

I do not understand
other people or
their views.

The horse is in me
and in you too

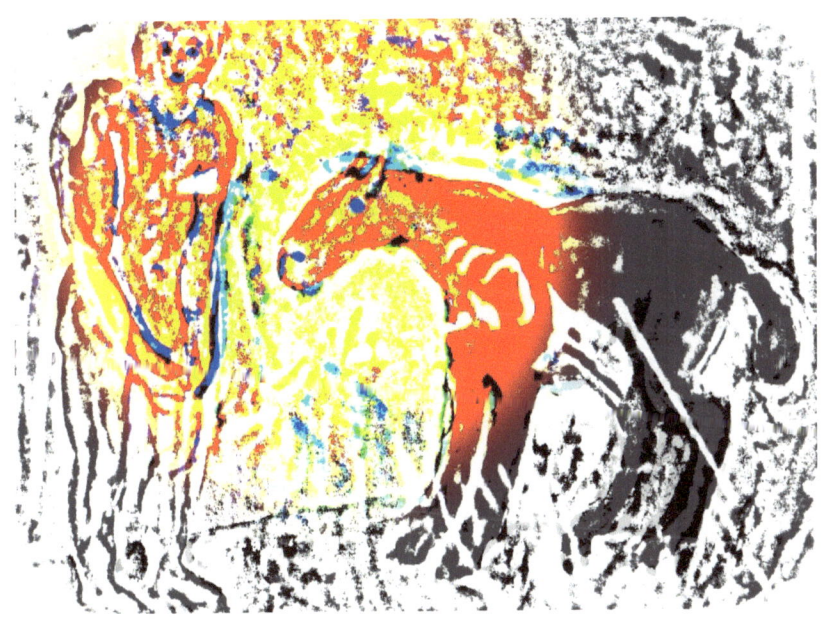

I am looking forward
to a meeting
between me and you
my horse
and the painting.

Black and white
horses
can also be
colorful.

You have to let go
and let the feelings go.
The more insecure
and clumsy you are
and less control
you have,
the better
is the horse

You have to let go
and let the feelings go.
The less control
you have,
the better.

It is not color,

but the light I paint.

Look here.

See how the light

illuminates the colors.

The light

creates the color.

It is not color,

but the light I paint.

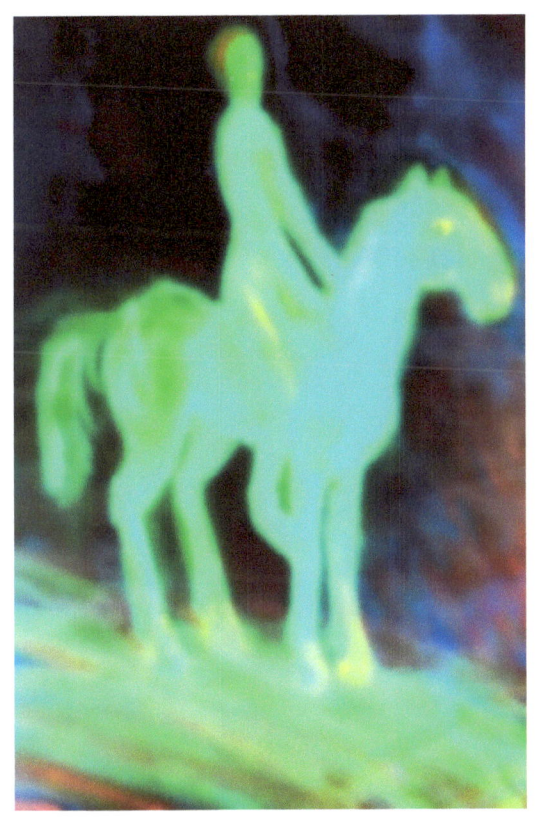

Some are keen
on control,
to be in control,
to know what's going on.

Others
are able to devote
themselves to
the extent
that they lose
control.

They drop out
and hope that
it is soil
where they land.

I have always painted
horses,
it has been almost
an obsession.

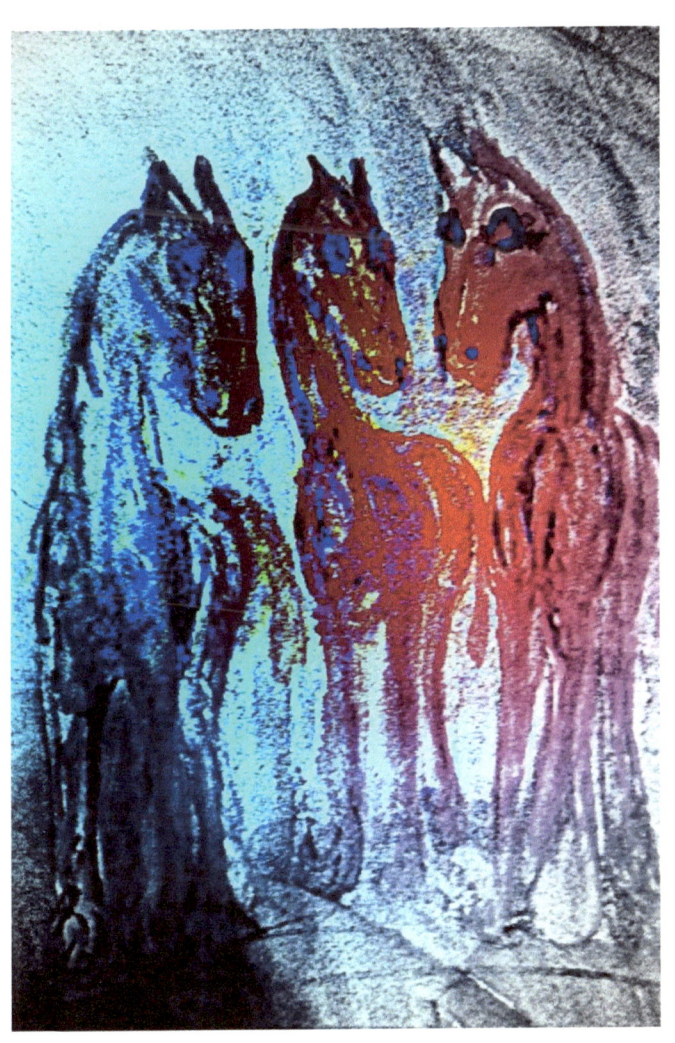

Mother and father
and I
in the background.
I was born
of a horse, but
I was not a horse.

My sister was
my horse
And I was her
head and will.
It has been almost
an obsession.

I have always painted
horses.
It has been almost
an obsession.
Where
did my horse go?
Why
did she leave me?

The horse is in me
and in you too,
I am looking forward
To a meeting
between me
the horse
and the painting.

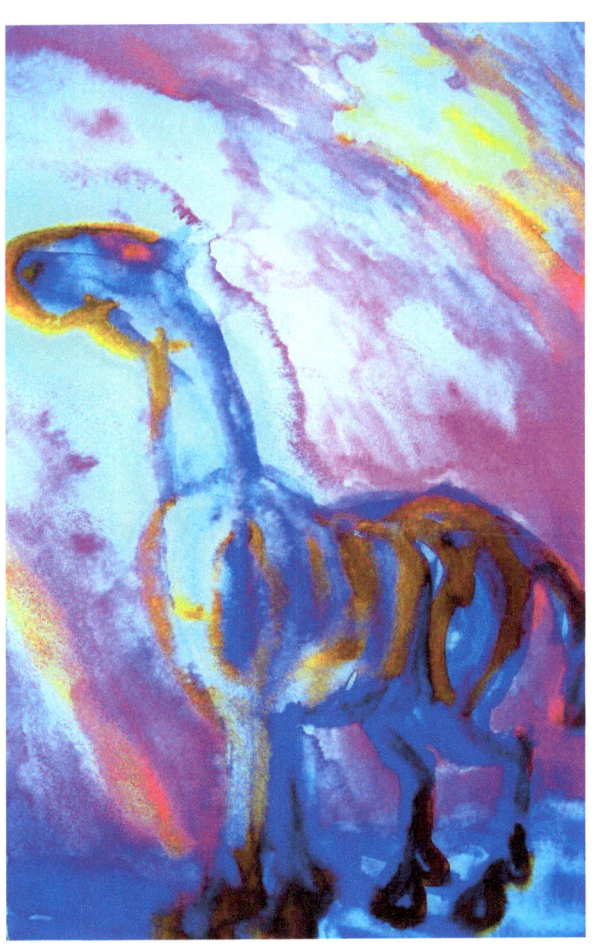

If you are painting
a horse,
you don't know
what it will be
in advance.

You have to let go
and let the feelings go.
The more insecure,
And clumsy you are
and less control you have,
the better is the horse.

Black and white horses

can also be colorful,

just look

at the light

in the woodcut.

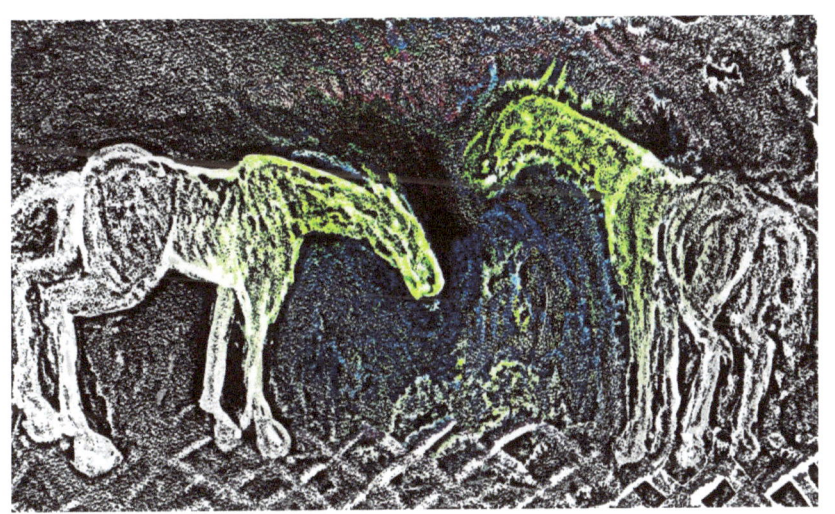

I paint my horses
because it's something
I cannot do.
There are swiftly memories
of the brushstrokes,
energetic and vibrant.

The soul's a horse.
The horse's soul.
Thighs
The feminine.
The sensuous.

A picture of three horses,

Mother, father and I

in the background.

I was born of a horse,

but I was not a horse.

My sister was my horse.

I was her head and will.

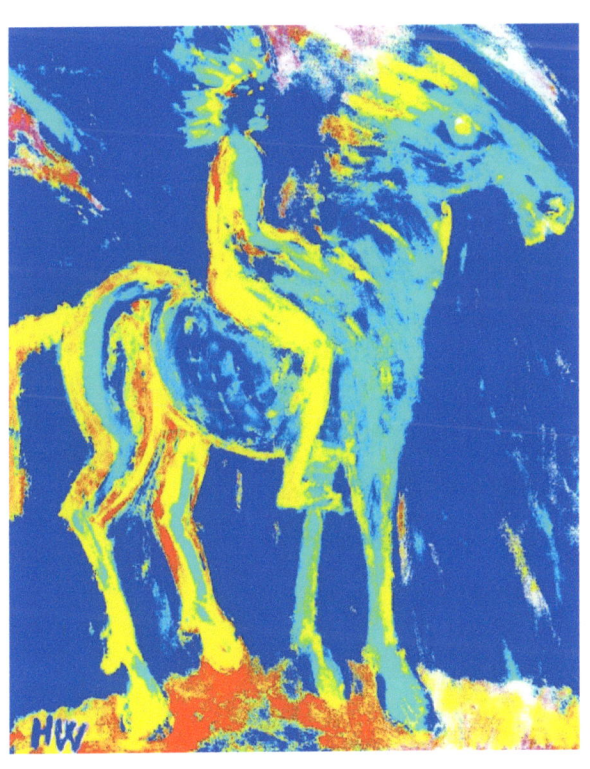

It has been almost
an obsession.
I have always painted
horses.
It has been almost
an obsession.
Where did my horse go.
Why did she leave me.

I have always painted horses.
It has been almost an obsession.

So it's time to
fight back against
critics who claim
that I am too
superficial.

I was born of a horse,

but I was not a horse.

Where are we now.

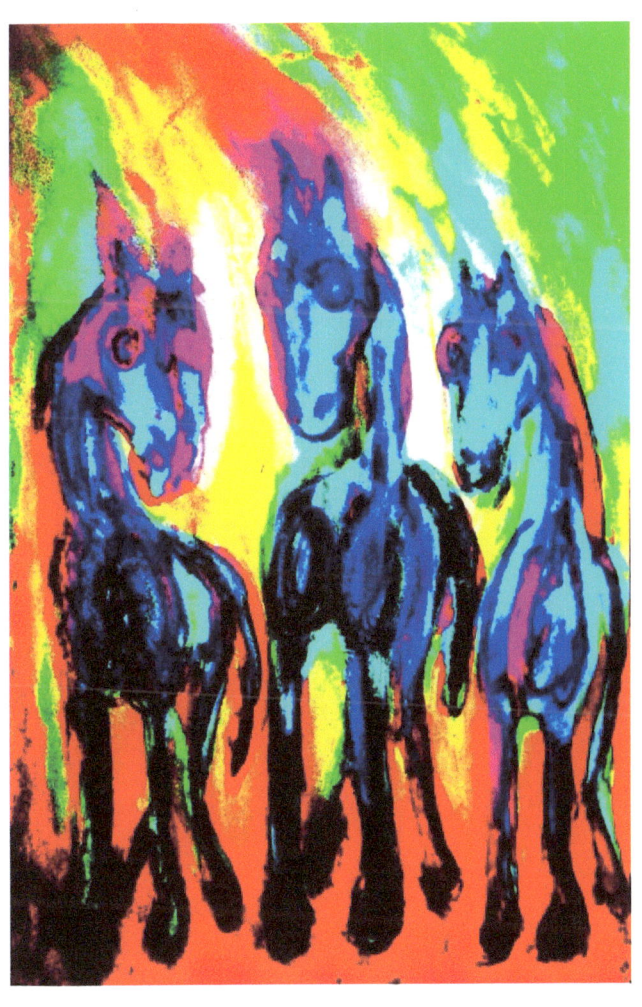

Mother and father and I
in the background.
I was born of a horse,
but I was not a horse.

My sister was my horse
And I was her head and will.
It has been almost an obsession.
I have always painted horses.
It has been almost an obsession.
Where did my horse go.
Why did she leave me.

It is hectic.

You are excited,

walking energetically

around in your studio.

We put our footprints on

the semi-wet canvases

stretched on the floor.

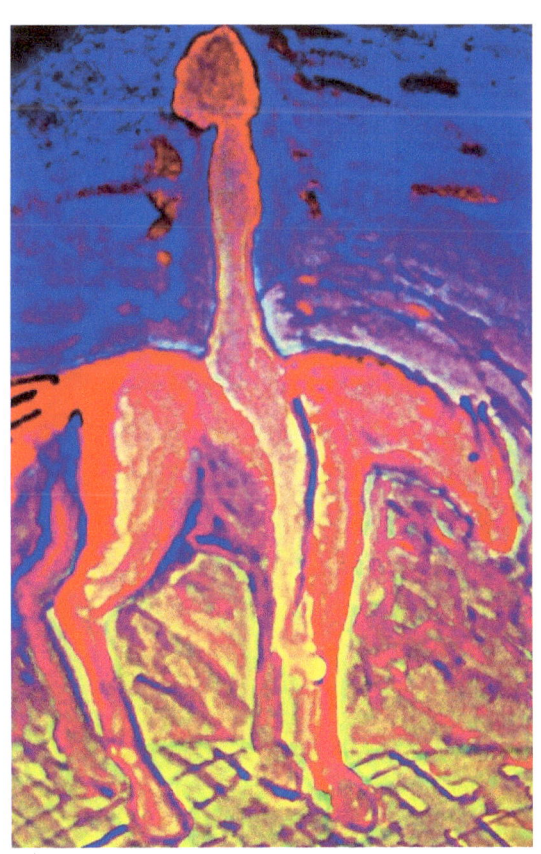

You are characterized
by a clenched energy.
One feels
almost physically
that you feel
it is time to fight
back against critics
who claim that
you are
too superficial.

You feel sore.
But you know
The images will
be made.

I have always painted
horses.
It has been almost
an obsession.

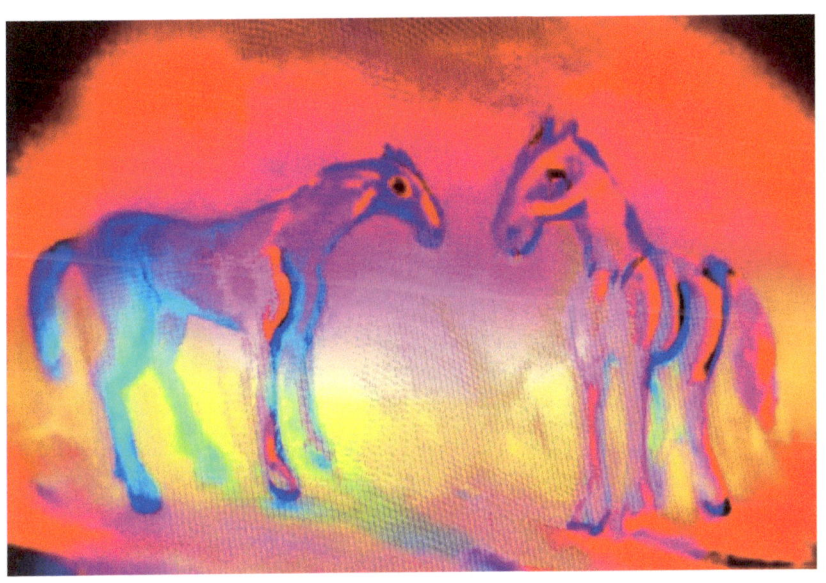

The soul's a horse.
The horse's soul.
The feminine.
The sensuous.

A picture of three horses.
Mother, father and I
in the background.
I was born of a horse,
but I was not a horse.
My sister was my horse.

I was her head and will.
It has been almost
an obsession.
I have always painted
horses.
It has been almost
an obsession.
Where did my horse go.
Why did she leave me.

I have read the book
of Job,
Ecclesiastes,
Old Testament.
Many people did.
All old people have
read the Bible.
It is heavy and
powerful.

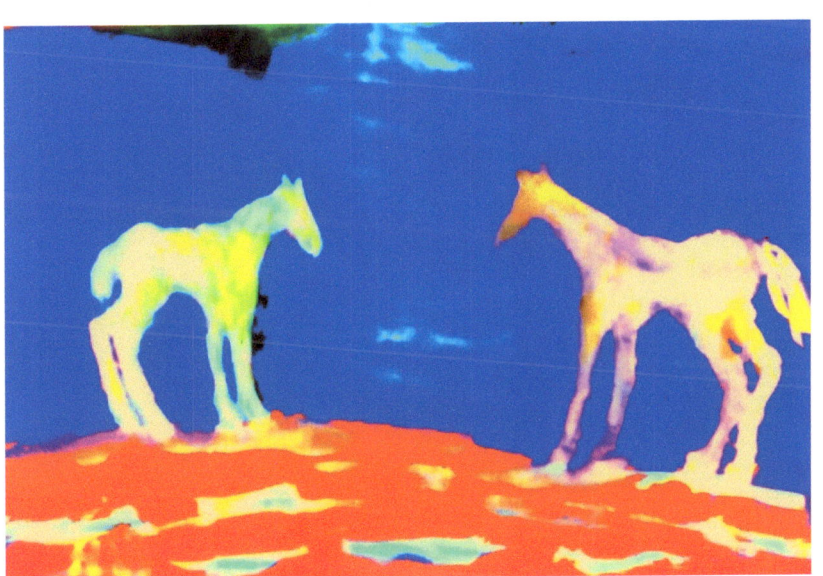

But I tend to carry
my church with me.
I have thought a lot
for myself,
in religious ways too.

I've never been good
at stopping by something.
I'm not good at listening,
And I'm not good
at discussing and
I do not understand
other people's views.

I am in love
with my painting,
it is a form
for sensuality.

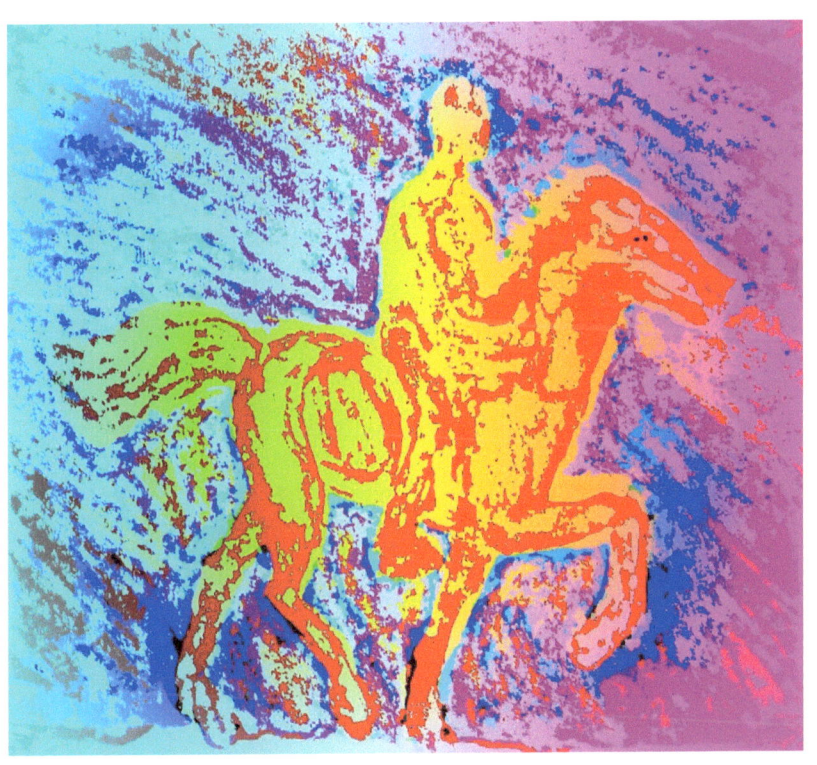

But I know
several people
who are just
as self-absorbed
as me.

Some people are keen
on control,
to be in control,
knowing
what's going on.
Others are able
to devote themselves
to the extent
that they lose
control.
I drop out
and hope
that it is soil
where I land.

I've forgotten everything
I said last time and
I cannot remember

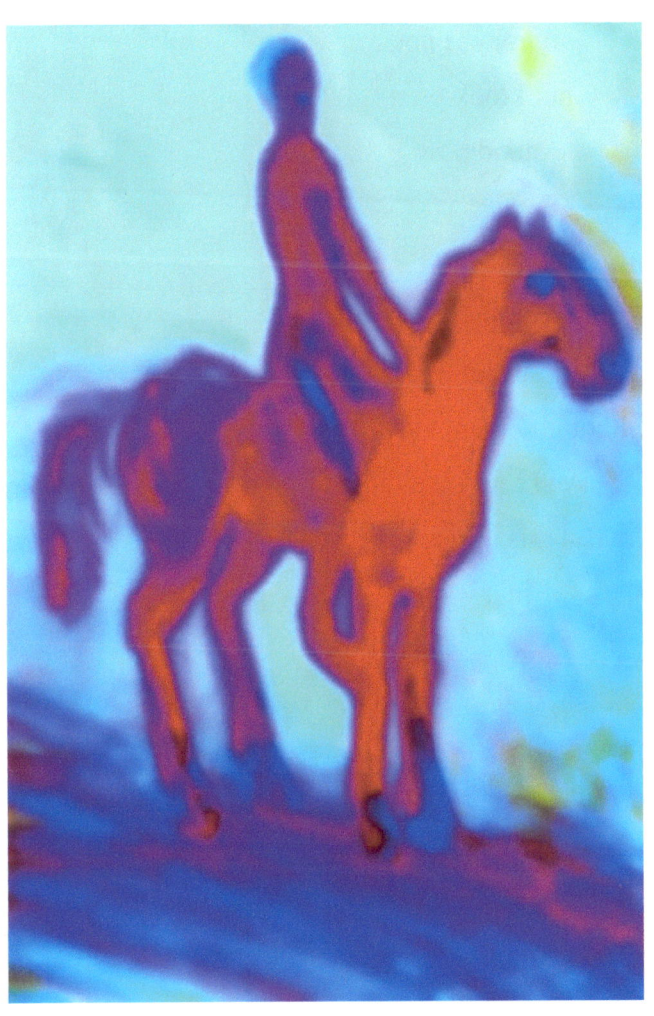

How I looked
On the pictures

It's important
how one looks
or maybe not,
but I look pretty
good now.

I do not enjoy life as much
as before,
although I paint every day.
And I forget a lot.
But this is also good,
in a way.

I don't have to fill my head

with so much.

And I'm not talking

as much as before.

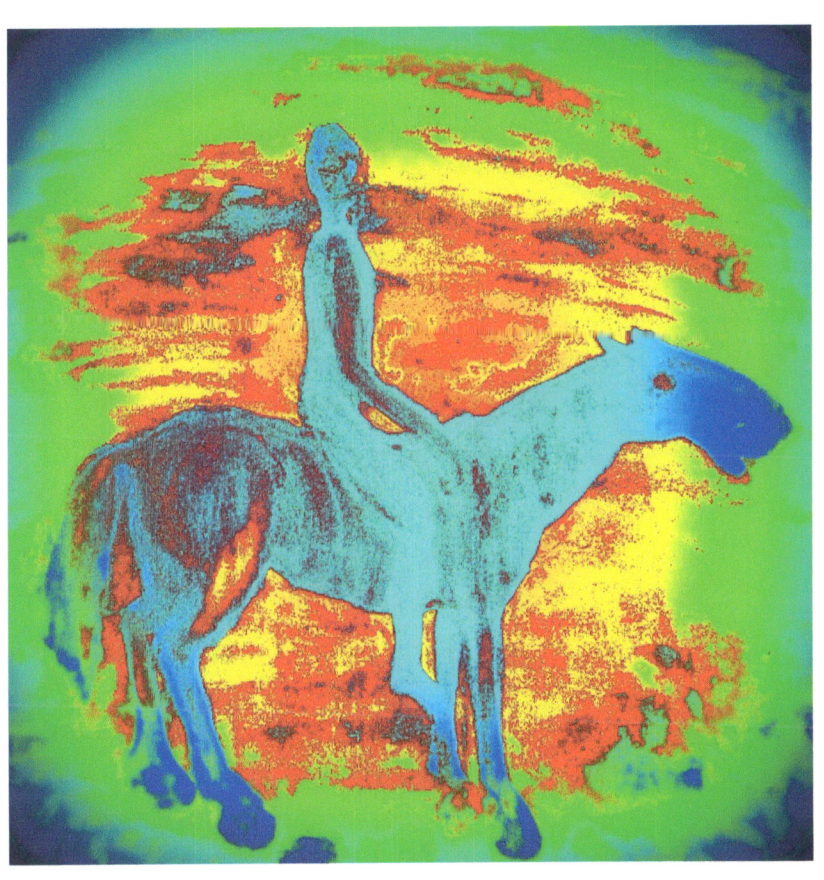

You smile,
A quiet little smile,
looking me deep
into my eyes
with a strong look.

It is not color,
but the light,

I paint.
Look here.
See how the light
illuminates the color
of the flower.
The light creates
the color.

The horse is in me
and in you too,
There is a meeting
between me,
the horse
and the painting.

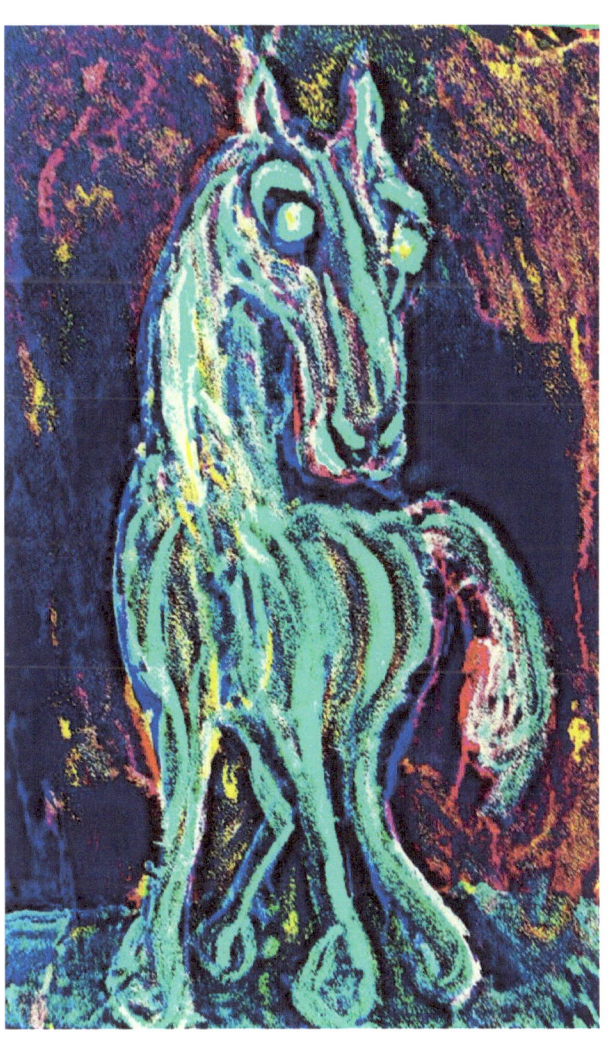

If you are painting
a horse,
you don't know
in advance
how it will be.

You have to let go
and let the feelings go.
The more insecure,
And clumsy you are
and the less control you have,
the better is the horse.

I paint my horses
because it's something
I cannot do.

There are swiftly memories
of the brushstrokes,
energetic and vibrant.

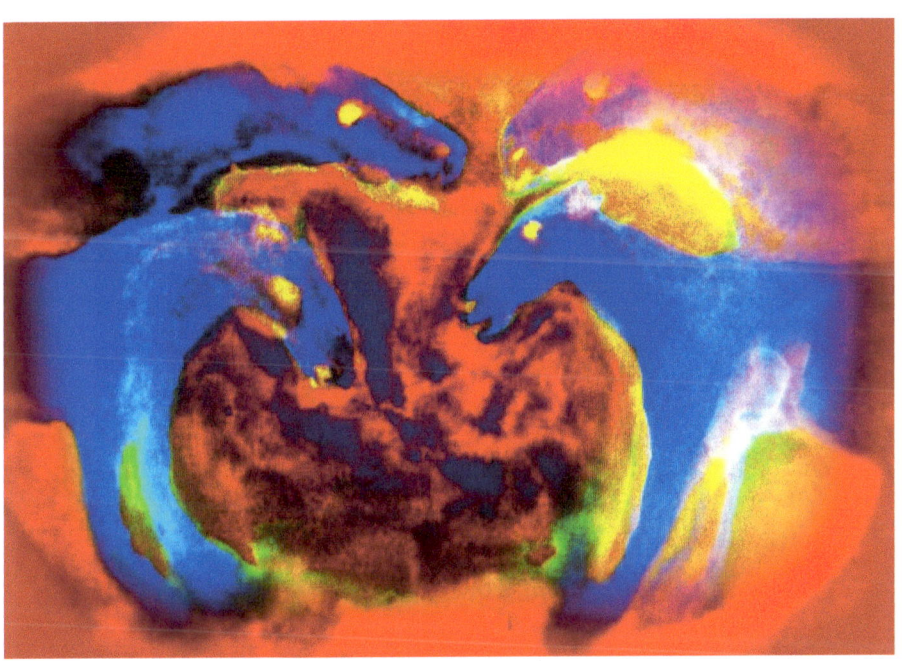

Black and white horses
can also be colorful,
just look
at the light
in the woodcut.

I have always painted
horses.
It has been almost
an obsession.
Mother and father
and me
in the background.
I was born
of a horse, but
I was not a horse.
My sister was
my horse
And I was her
head and will.
It has been almost
an obsession.

I have always painted
horses.
It has been almost
an obsession.

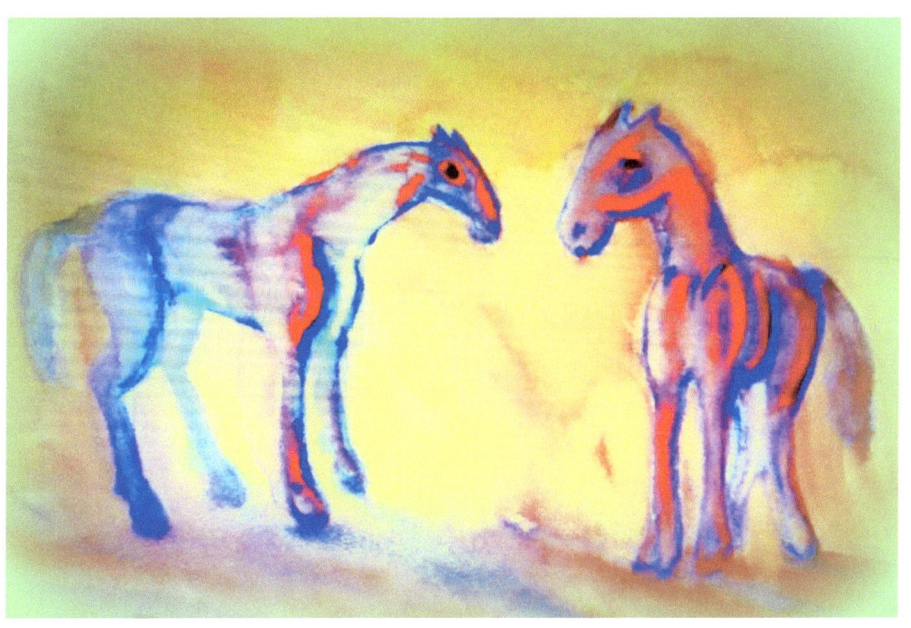

Where
did my horse go.
Why
did she leave me.

My subjects came to me
As from a different dimension,
a spiritual sphere,
but now it strikes me
that it is life
here and now,
I am painting
in real colors.

riders are just ordinary
people who ride around.
There is nothing
heroic about it.

I do not live

with a lot of people

as before,

and I cannot get

the same contact

with people

and I do not understand

in the same way.

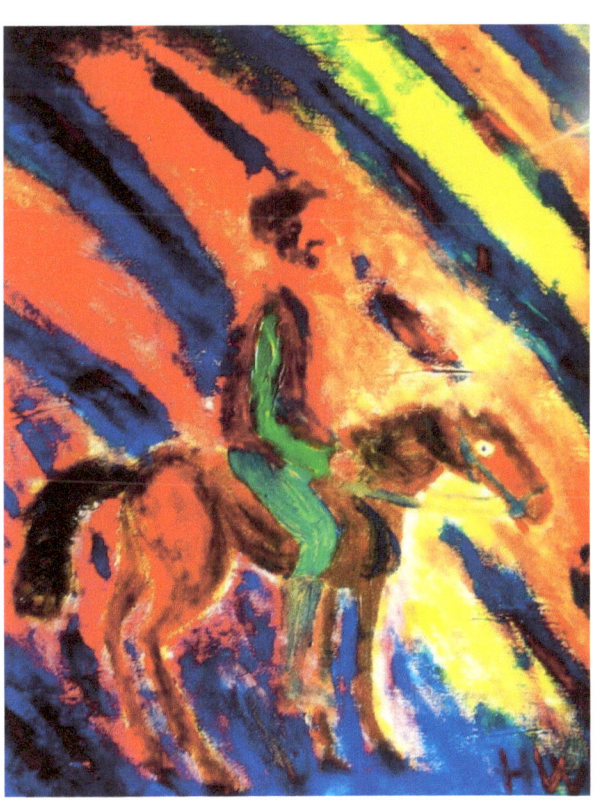

Instead,
I live closer
to the pictures,
and I think even more
than I paint.

What is the problem
In repeating oneself
You connect
To an understanding
of art as an expression
of the innermost
feelings.

Light is the key
element
in the pictures,
and Light plays

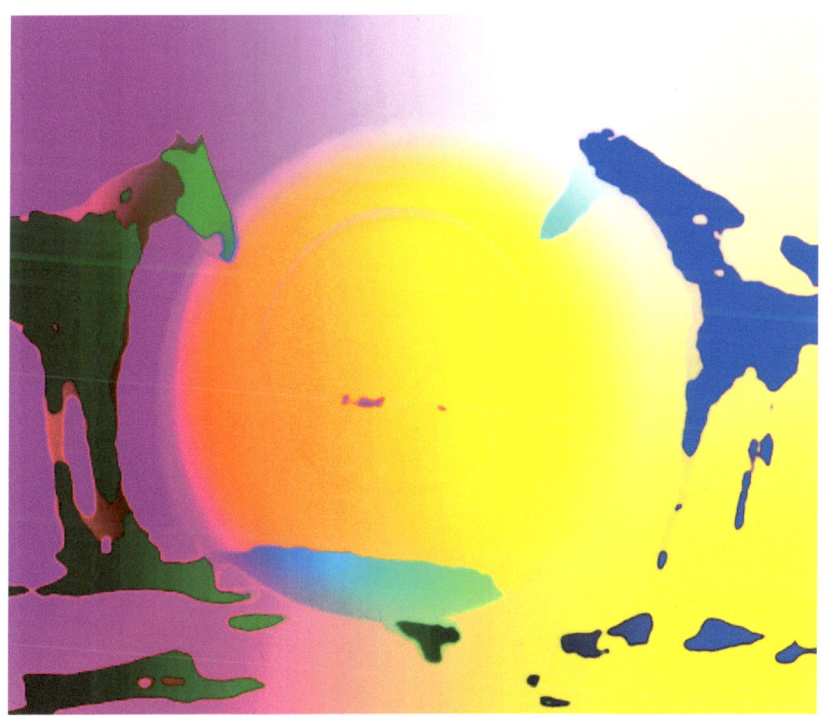

not only the role
of significant funding,
it is also light
the images thematically
circle around.

the light represent
vitality
and natural growth
forces
in a landscape
lightened
of sunshine.

the love glows
between two people,
or it is spiritual growth,
or existential longing.

the use of light
in the image
makes us ascribe
a religious theme.
The continuous
circling
of the light.

Not only soul light,

but also sunlight,

or the one reflected

in the other.

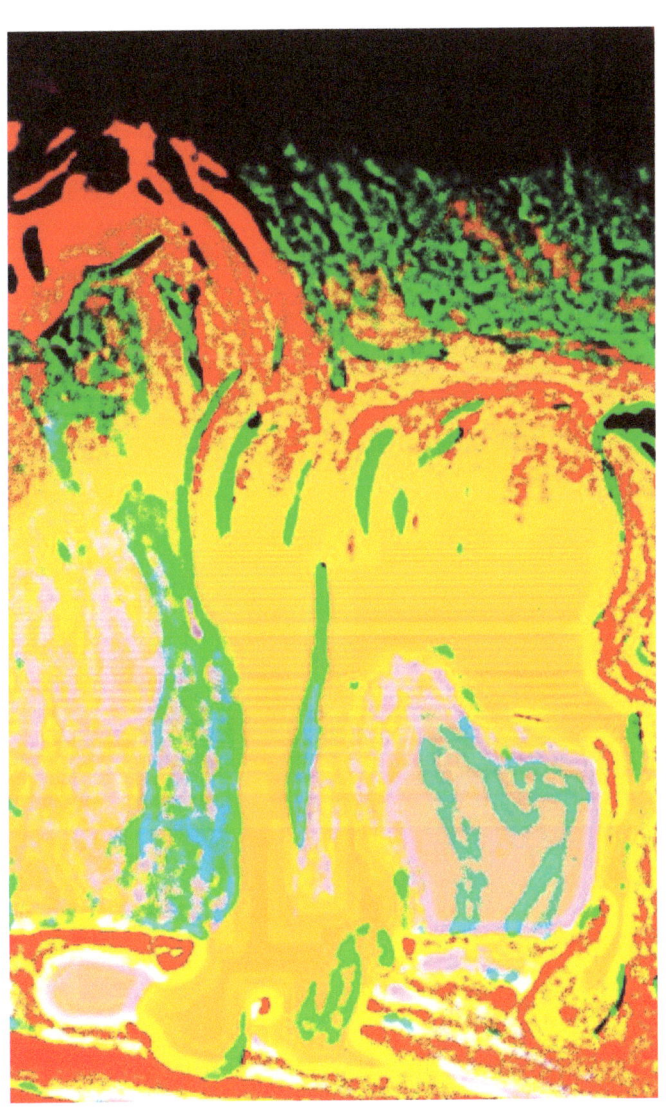

the elongated figures
make it tempting
to imagine
the human figure
the rising sun,
where the outline disappears
into the surrounding
refractive figure.

You circuit about
Your existential issues.
This fascination with light
ability to prey
on the matter we see
in extended use of the human
figure in silhouette,
seems to have been contributing
for living creatures
distinctive appearance.

You have to let go

and let the feelings go.

The more insecure,

And clumsy you are

and less control you have,

the better

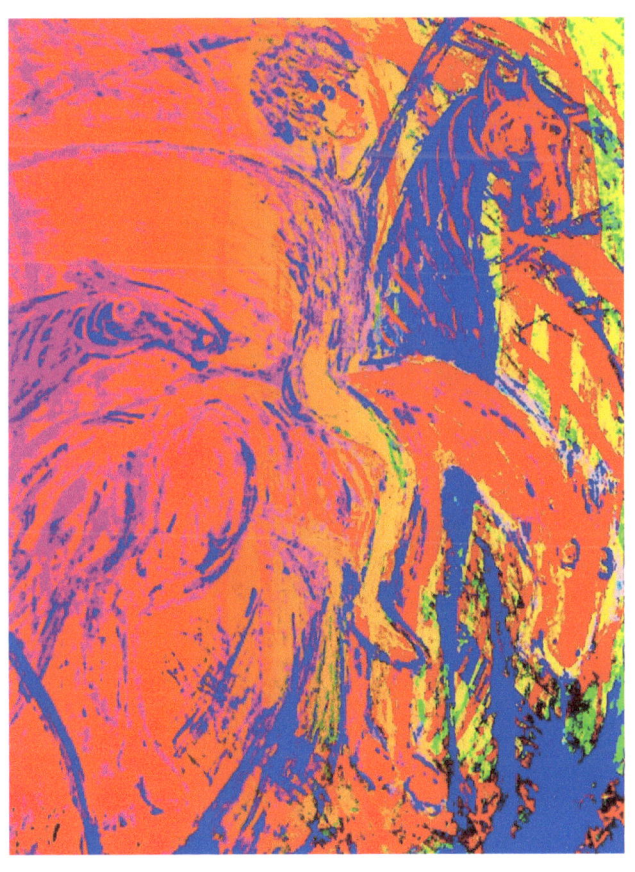

There are some
who are keen
to control,
to be in control,
knowing
what's going on.
Then
there is the other
character type,
which is able
to devote themselves
to the extent
that one loses control.

I'm not good to listen,
And I'm not good
At discussing and
I do not understand
other people's views.

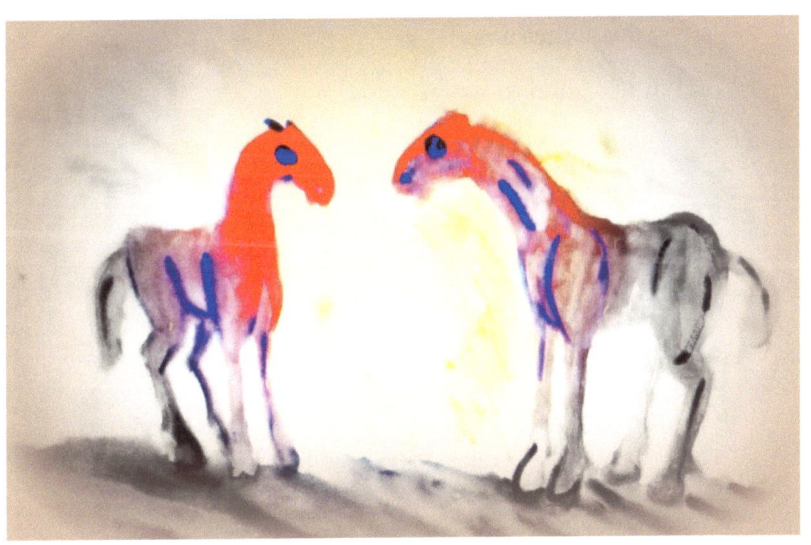

You have to let go
and let the feelings go.

The more insecure,
And clumsy you are
and less control you have,
the better

I have thought
A lot for myself,
But I've never
been any good
to stop
by something.
I'm not good to listen,
And I'm not good
At discussing and
I do not understand
other people's views.

I have always painted
horses.
It has been almost
an obsession.

Mother and father

and I

in the background.

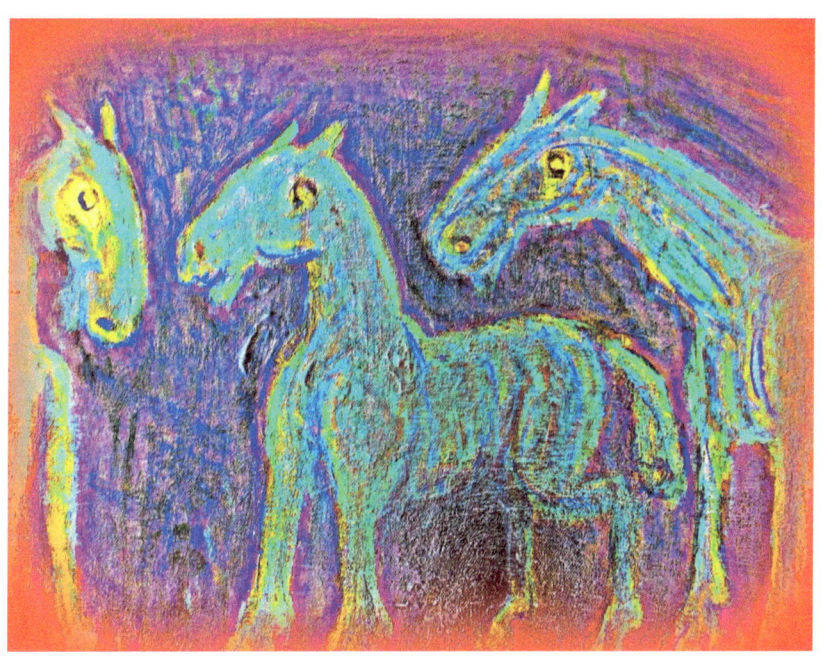

I was born

of a horse, but

I was not a horse.

My sister was
my horse
And I was her
head and will.
It has been almost
an obsession.

I have always painted
horses.
It has been almost
an obsession.
Where
did my horse go.
Why
did she leave me.

You circuit about
Your existential issues.

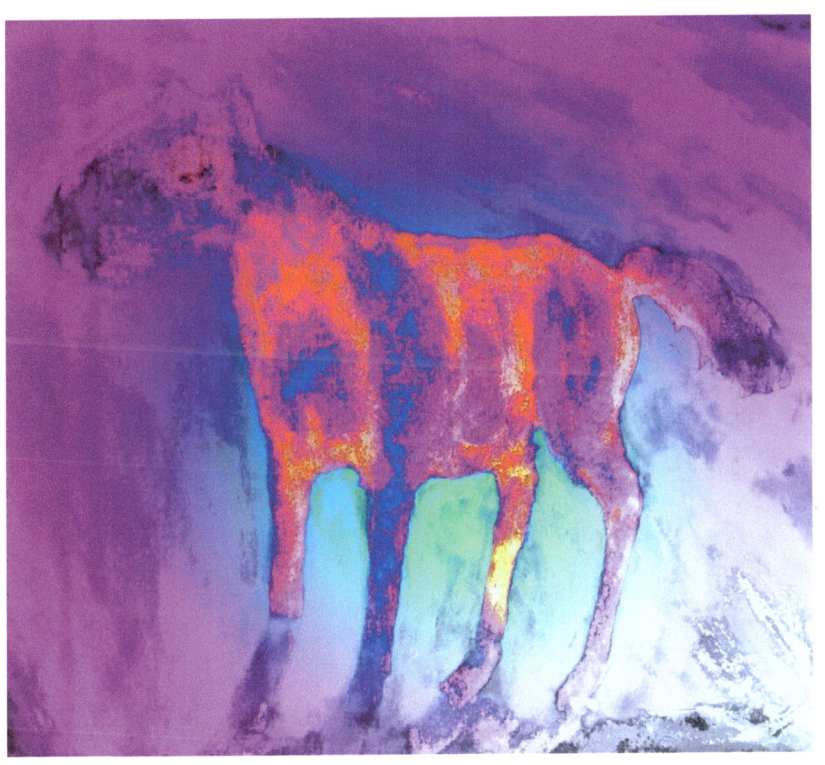

The separate images
are generally worn
by a simplified
existential rhetoric.

say that your pictures
show people in the tension
between freedom
and security,
with classic freedom
metaphors.
So you circuit
about your existential
issues.

You keep the viewer
at a distance.
You walk,
float or
spiral out of reach,
alone
or in your heroic
solitude.

You also deal
with anxiety,
but not painted
into the pictures
as a theme.

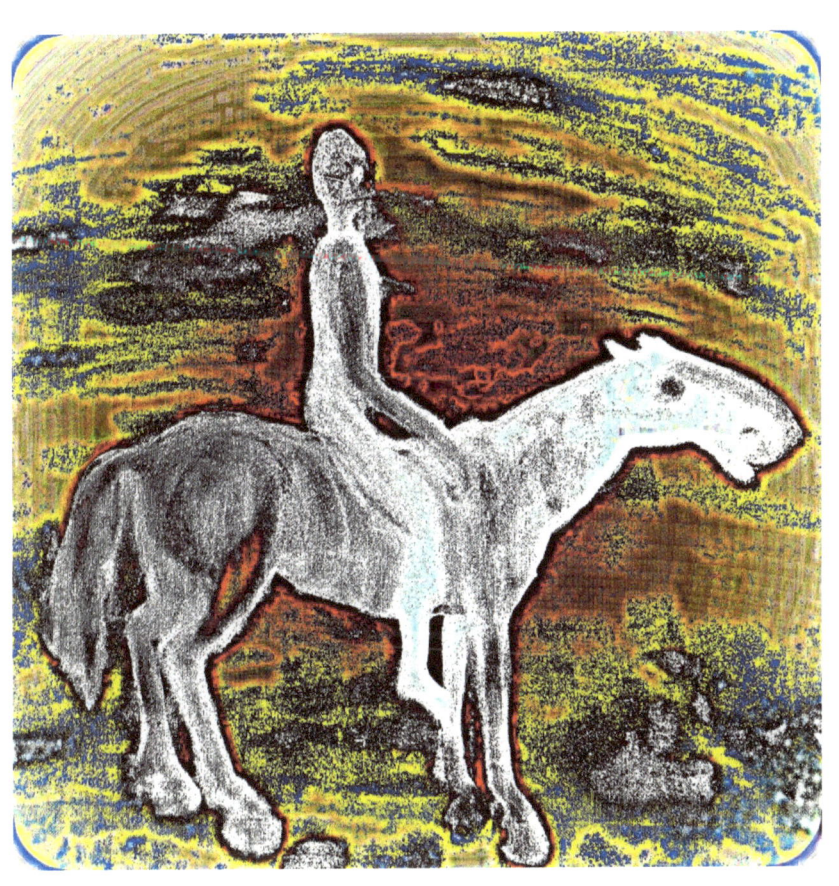

Anxiety occurs

because you abolish
the fundamental nature
of regularities
in the images.
the screaming figure
is elusive and intangible.

In a similar way
You challenge
laws of nature
as you dissolve gravity
People meet,
They form community
and even love.
But despite this
Life is about
loneliness.

I have always painted
horses.
It has been almost
an obsession.

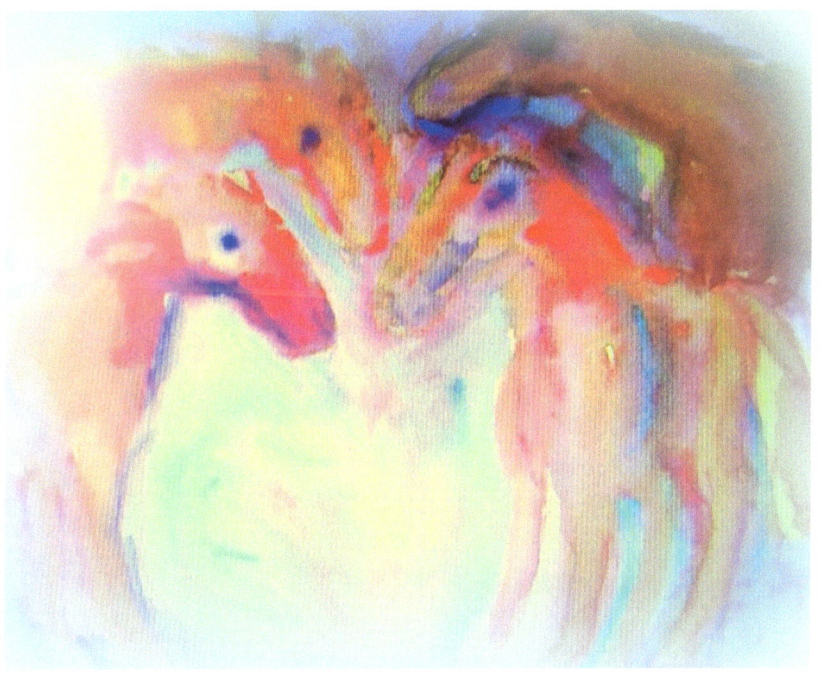

Mother and father
and I
in the background.
I was born
of a horse, but
I was not a horse.

My sister was
my horse
And I was her
head and will.
It has been almost
an obsession.

I have always painted
horses.
It has been almost
an obsession.
Where
did my horse go.
Why
did she leave me.

You walk,
float or
spiral out of reach,
alone
or in your heroic
solitude.

Life is about

Loneliness

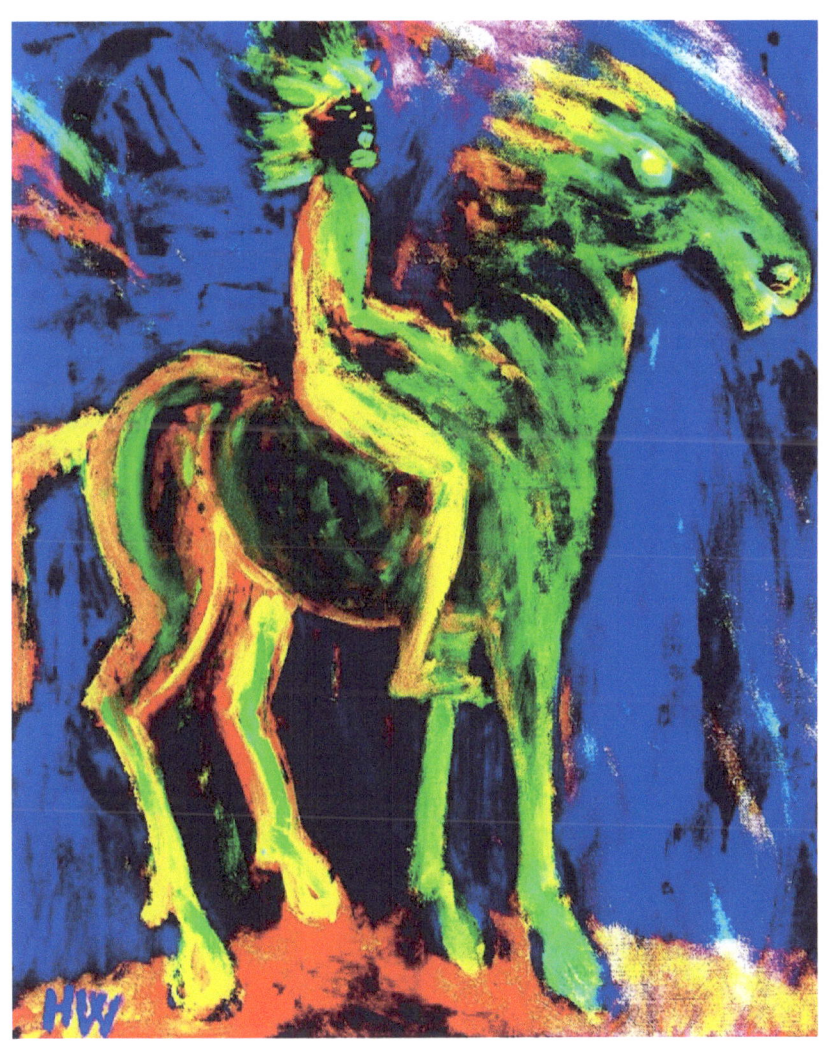

This is not

about individuals

but about a timeless
human existence.

The characters
we are confronted with
must be understood
as allegories
of human qualities
or concepts.
They are presented
without a face
or identity,
and they are not individuals
with personal characteristics,
they are more
general human

As representatives of man
They shall
be born and live
in solitude and cohesion,
as love in pain and joy,

they are not individuals
with personal characteristics,

they are more
general human
This is not
about individuals,
but about a timeless
human existence.

It is not a real war
we are confronted with,
but war as an eternal
dark quality
of human life.
But do we care?

It is not a real war
we are confronted with,
but war as an eternal
dark quality
of human life.

It is not a real war
You confront us with,
but war as an eternal
dark quality
of human life.

The allusion of something
universal and timeless
makes your images
in danger
of being empty clichés.

For what do we care
of Birth, Death or Love
in general?
It is not a real war
You confront us with,
but war as an eternal
dark quality
of human life.
But what do you care

I have always painted
horses.
It has been almost
an obsession.
Mother and father
and I
in the background.
I was born
of a horse, but
I was not a horse.

My sister was
my horse
And I was her
head and will.
It has been almost
an obsession.

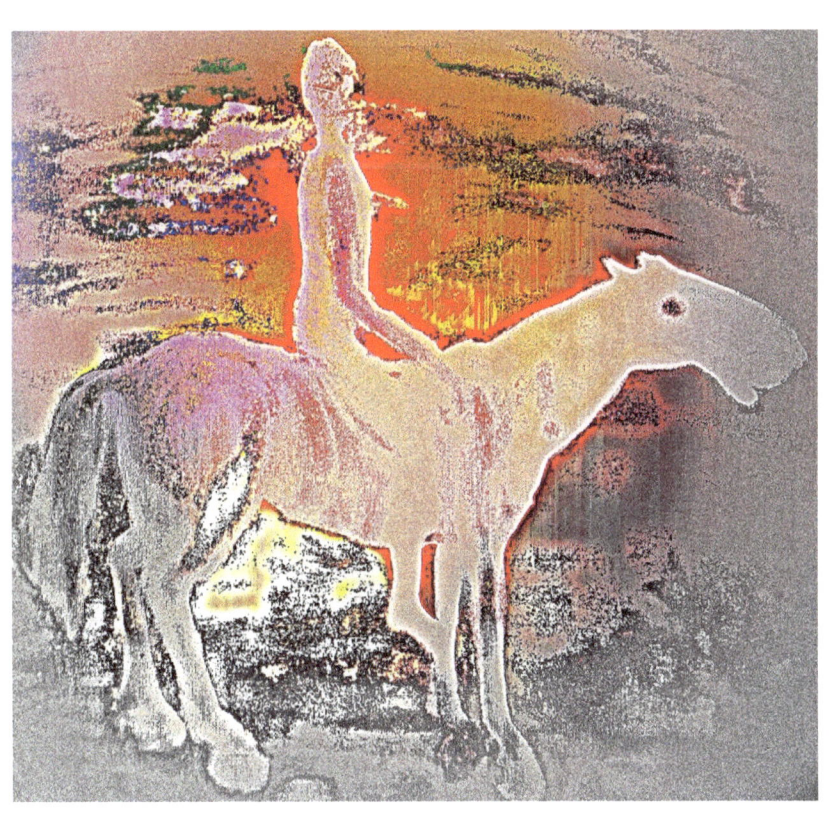

I have always painted
horses.
It has been almost
an obsession.
Where
did my horse go.
Why
did she leave me.

the images express
a fervent ambition
to convey eternal
truths about reality.
Your artistic project
is a quest
for knowledge,
The brain knows and
the eye look.
You want to know
what you see,
and see
what you know.

This is not an exploration

of the painterly medium

as such

or concept of art

changing status,

but the way the visual

and the rational

and knowledge

of life itself.

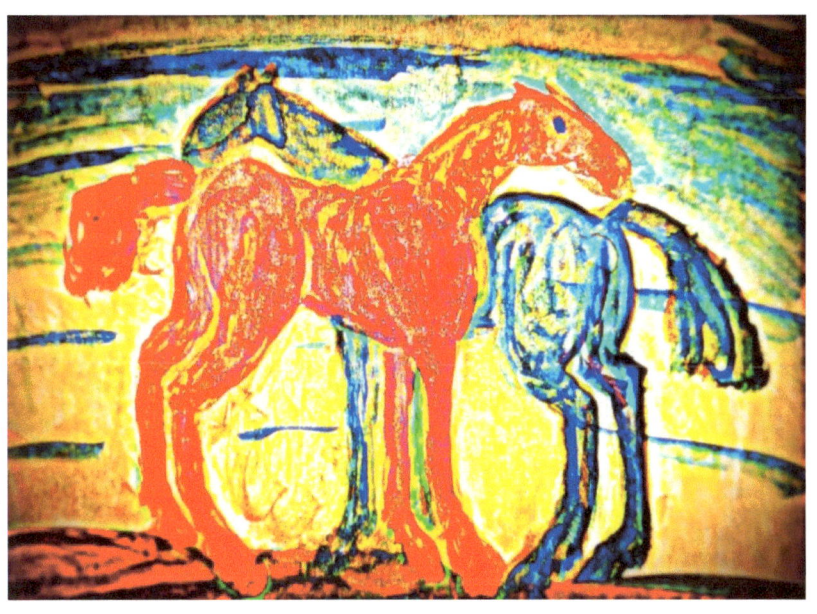

You maintain

your pictures

as a medium

with a privileged

access to reality.

You convey a genuine

belief in the painting

and its ability

to convey something

of an inner and

an outer reality.

You do not see

the painting

as one discourse among many.

You see it as

the way

to reach understanding.

I have always painted
horses.
It has been almost
an obsession.

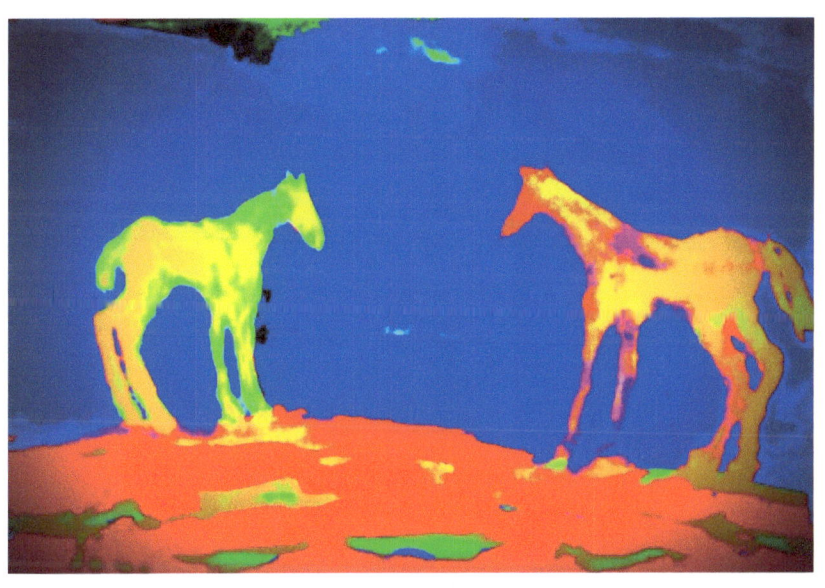

Mother and father
and I
in the background.
I was born
of a horse, but
I was not a horse.

My sister was
my horse
And I was her
head and will.
It has been almost
an obsession.

I have always painted
horses.
It has been almost
an obsession.
Where
did my horse go.
Why
did she leave me.

One may wonder

if a prerequisite

for a painting

is to be relevant today,

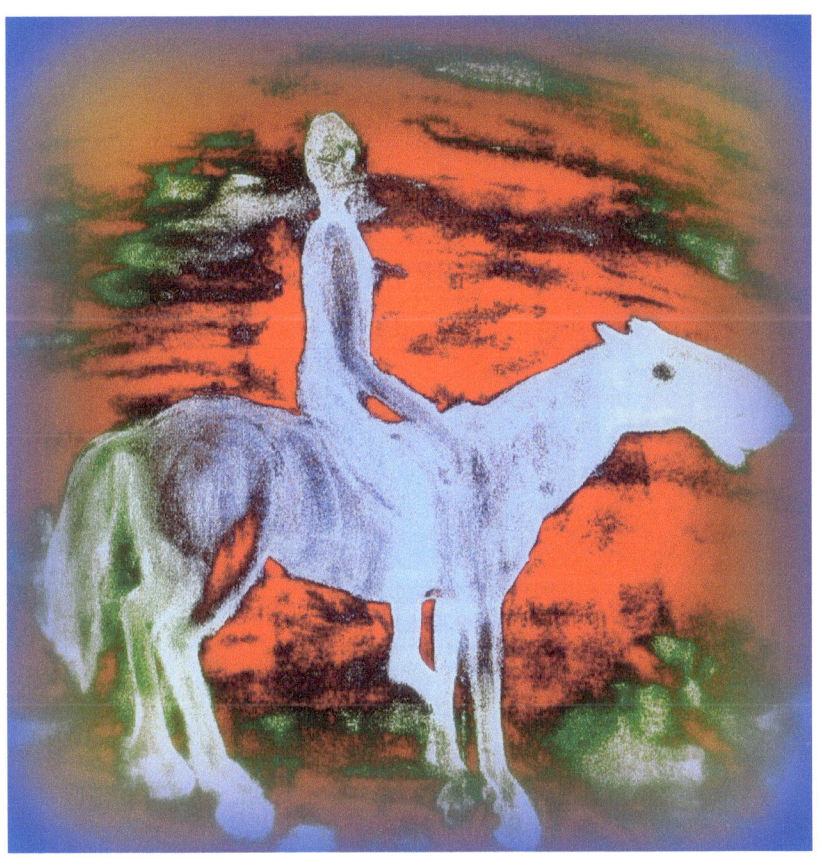

and to some degree involve

a critical awareness

of the historical

situation.

But this consciousness
is entirely absent
in your project.

You have to let go
and let the feelings go.
The more insecure,
And clumsy you are
and less control you have,
the better is the horse.

You borrow freely
shapes and forms from
a broad historical tradition.
You let yourself inspire.
You are an impressionist
expressionist
or a symbolic
surrealist,
these style designations
are more than
a hundred years old.

You are a national icon,
an unstoppable artist
more loved
than controversial.

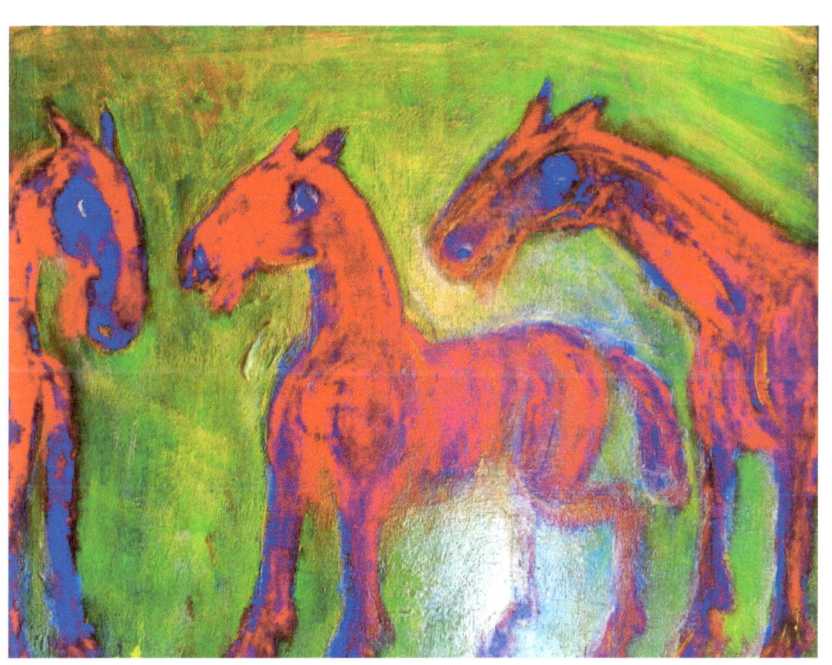

Yet we grown tired of you,
Your pictures are
exhausted,
we saw it all
twenty years ago.
But you don't give up.

What is it with you?
Why can't you stop?
Have you forgotten
that you have done it all
before?

I have always painted
horses.
It has been almost
an obsession.
Mother and father
and I
in the background.
I was born
of a horse, but
I was not a horse.
My sister was
my horse
And I was her
head and will.
It has been almost
an obsession.

I have always painted

horses.

It has been almost

an obsession.

Where

did my horse go.

Why

did she leave me.

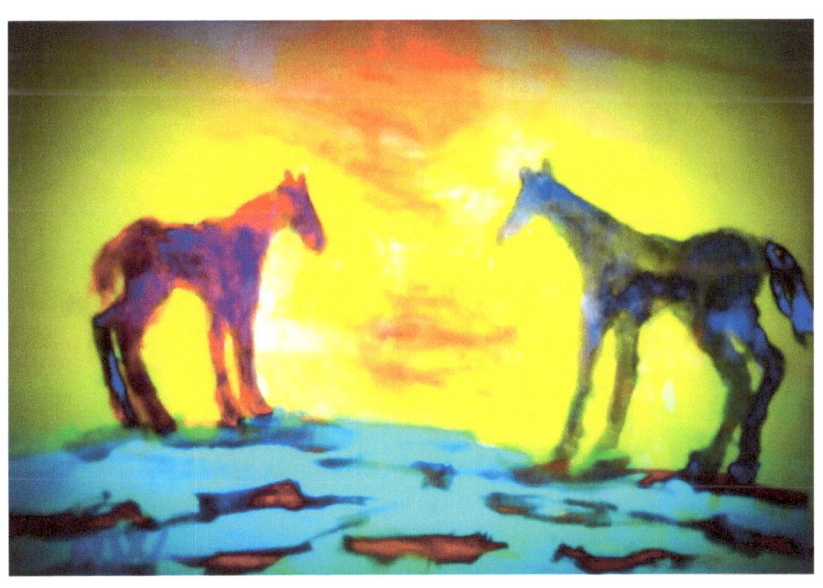

She died

And now

nobody

Understand me

www.ingramcontent.com/pod-product-compliance
Lightning Source LLC
Chambersburg PA
CBHW040810200526
45159CB00022B/135